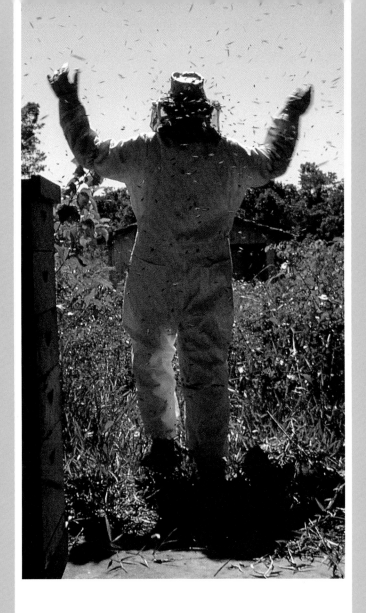

KILLER
BEES

TEXT AND PHOTOGRAPHS BY
BIANCA LAVIES

DUTTON CHILDREN'S BOOKS
NEW YORK

ACKNOWLEDGMENTS

For sharing time and knowledge,
the author wishes to thank:

Dr. Orley Taylor, Department of Entomology,
University of Kansas

Dr. Albert Green, author of the chapter
on yellow jackets in *The Social Biology of Wasps*
(Cornell University Press, 1991)

Map data by Dr. Orley R. Taylor,
University of Kansas,
and Dr. John G. Thomas,
Texas A&M University.
Map designed by Sylvia Frezzolini

Library of Congress Cataloging-in-Publication Data
Lavies, Bianca.
 Killer bees/text and photographs by Bianca Lavies.
 — 1st ed. p. cm.
 ISBN 0-525-45243-5
 1. Africanized honeybee—Juvenile literature.
[1. Africanized honeybee. 2. Bees.] I. Title
QH568.A6L326 1994 94-18581
595.79'9—dc20 CIP AC

Published in the United States 1994
by Dutton Children's Books,
a division of Penguin Books USA Inc.
375 Hudson Street, New York, New York 10014

Designed by Sylvia Frezzolini
Printed in Mexico First Edition
10 9 8 7 6 5 4 3 2 1

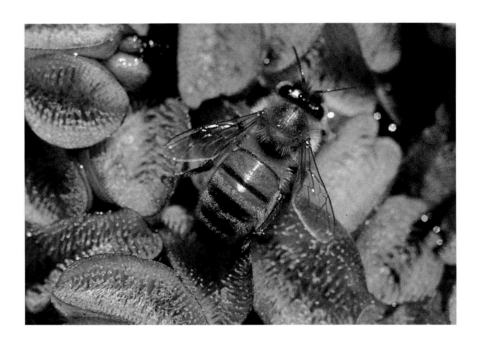

To Tom and Charlene Valeri, with my love

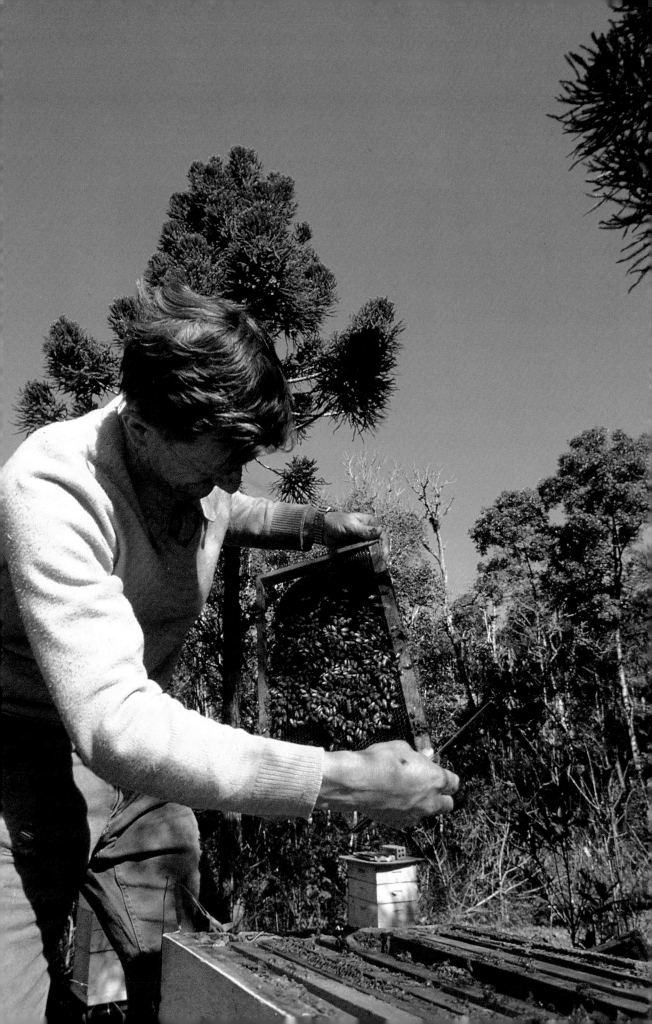

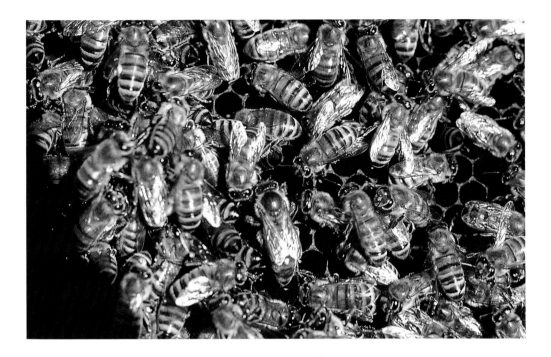

We humans like to eat what tastes sweet. Foods such as apples, strawberries, and cherries are naturally sweet. Cookies, cake, and ice cream we make sweet by adding sugar that comes from sugarcane or sugar beets. At some time, long ago, humans also discovered the sweet taste of honey, a food made by bees. For thousands of years, people have kept bees in hives in order to use their honey. A modern-day beekeeper is checking for honey in a hive at left.

Honeybees are social insects. They live together in colonies of around fifty thousand individuals. Each colony has one queen. In the photo above, you can see her in the center of a group of worker bees. She is the large bee with the dark, shiny middle, or thorax.

The queen bee is the mother of the colony. After mating with a dozen male bees, or drones, the queen lays her eggs—from a hundred to three thousand a day for the several years that she lives. Some of the eggs become drones, but most become female workers. As their name indicates, they do the work of the colony. Though they are female, they do not usually reproduce. They build, maintain, and defend the colony's nest, as well as care for the queen and her young.

It is believed that the first honeybees appeared on earth millions of years ago in the area that is now Asia. From there they migrated westward. Some ended up in what is now Europe, and others on the landmass of Africa. The very different climates of the two areas affected the habits and temperaments of the bees as they evolved. Eventually two distinct varieties emerged.

The European bees adapted to an environment with cold winters and few predators. They nested in tree hollows and other high, sheltered spots that offered protection from the harsh weather and from such enemies as mice, bears, and humans. Because the bees' nests were rarely attacked, aggressive stinging behavior was not a trait that played a strong role in the evolution of European bees.

Different traits developed in the bees living in the hot, tropical climate of the African continent. Unlike European bees, these bees tended to build their nests in open, ventilated places, like the roof pictured at right, that offered relief from the heat. They also nested closer to the ground, sometimes even in holes in the earth, where it was cool. These locations were more vulnerable to attack from predators—army ants, honey badgers, birds, and humans. And these bees were also more likely to be disturbed by accident. Over time, the African bees adapted by stinging more readily and in greater numbers to defend their nests.

Three hundred or so years ago, European settlers traveled across the Atlantic Ocean to the Western Hemisphere, bringing honeybees with them. The European bees thrived in the temperate climate of the northern part of the New World, where the cold winters and mild summers resembled their native climate in Europe. But the honeybees brought to the southern part of the hemisphere were not so well suited to its tropical, year-round warmth.

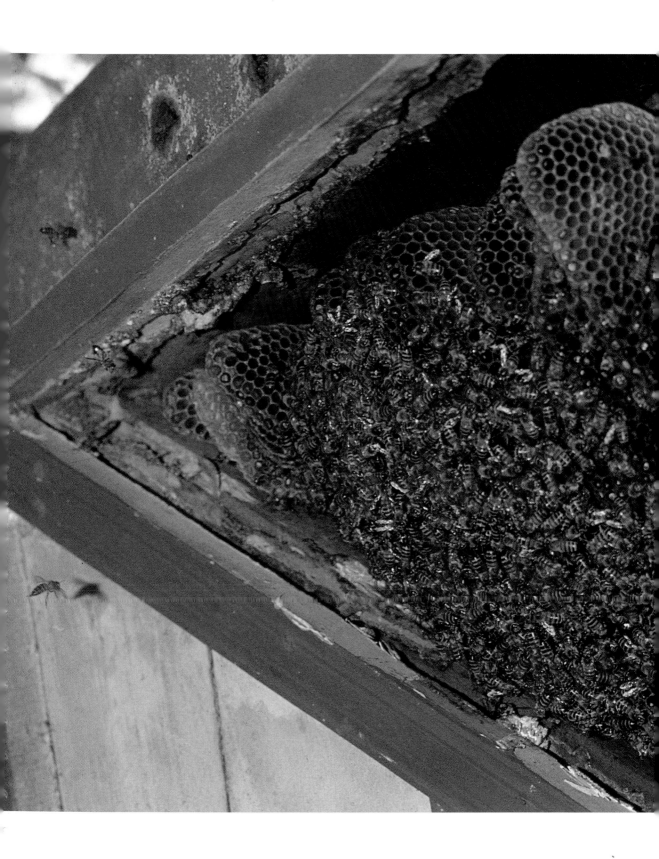

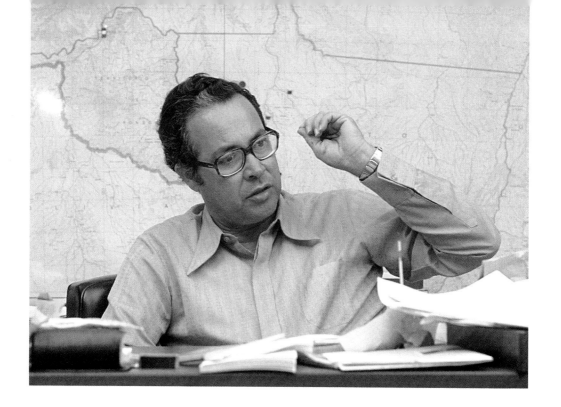

Many, many years later, in the mid-1950s, beekeepers in Brazil sought to improve the honey production of their bees—bees descended from those original European bee colonies. They had heard that some beekeepers in Africa were getting an average of 150 pounds of honey per year from their colonies, a lot more than the honeybees in Brazil produced. A scientist named Warwick Estevam Kerr, pictured above, was asked by the Brazilian government to go to Africa and bring back some African queens. The government hoped that by mating African queens with the European drones already in Brazil, a more productive breed, well suited to the tropical climate, would emerge. European and African honeybees are able to mate with one another because they are members of the same species, *Apis mellifera*. Though they have different behaviors, they look very much alike.

Dr. Kerr returned with thirty-five African queens. He placed each one in a colony of European bees, so it could mate with European drones. He did not know what exact traits the offspring might have, but he suspected that in addition to good honeymaking, they might exhibit aggressive behavior. Therefore he chose isolated spots for

the hives. And because he did not want the queens to escape and mate with drones in the wild, each hive contained a narrow, slotted grill called a queen excluder. This device, shown in the picture below, allowed the smaller workers to come and go, gathering nectar, but kept the queens inside.

For a while, everything went fairly well. The offspring of the crossbreeding, called Africanized honeybees, did indeed prove aggressive, but it was thought that further breeding with European drones would produce a gentler strain.

A year later, however, a visiting beekeeper removed some of the queen excluders by accident. Twenty-six African queens and their swarms of workers escaped into the wild. There the queens mated with European drones. The descendants that survived in the wild inherited the African trait of building low or underground nests along with the trait of high defensiveness, making them well suited to survival in Brazil's tropical, predatory environment. The colonies of Africanized honeybees quickly multiplied and spread out from Brazil. It is now estimated that there are more than one trillion Africanized bees in the Americas.

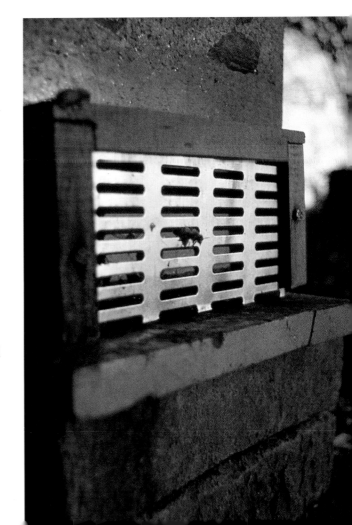

Africanized honeybees have another, more popular, name: killer bees. The name reflects the bad reputation they've earned by their aggressive, and sometimes deadly, attacks on humans and animals.

Honeybees do not sting because they are "mean" insects. They sting only to defend their colonies. When a colony of European bees is attacked, usually only a few worker bees pursue and sting the intruder. But it is not uncommon for hundreds of Africanized honeybees to sting when their nest is disturbed, especially if the nest is large and filled with honey. Here you can see Africanized honeybees attacking the author-photographer, who is wearing a protective bee suit.

When a bee thrusts its poisonous, double-pointed stinger into skin, jagged barbs along the outside hold the stinger in place as the bee pulls away. As the stinger is torn from the bee's abdomen, it triggers a gland to release an alarm odor. The odor marks the victim for attack by other bees from the nest. Africanized bees release more of this alarm odor than European bees, so more of their nest mates are likely to respond to it.

The venom of an Africanized bee is no more poisonous than that of a European bee. But because Africanized bees sting in such great numbers, they leave more venom in their victims. Though the effects of beestings on people vary, stings numbering in the hundreds will make most victims seriously ill. One sting is enough to threaten the life of someone who is allergic to bee venom.

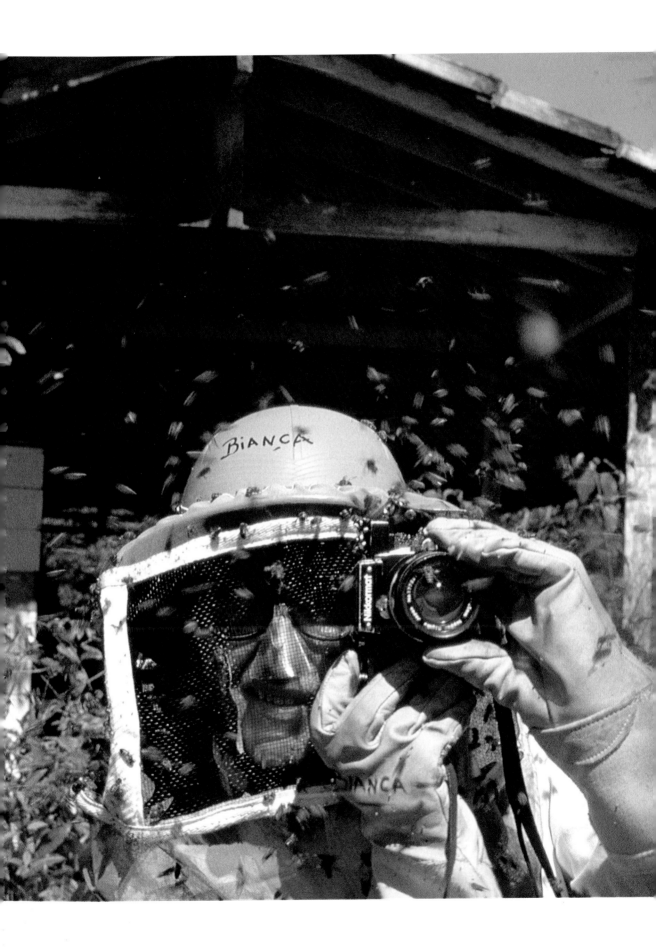

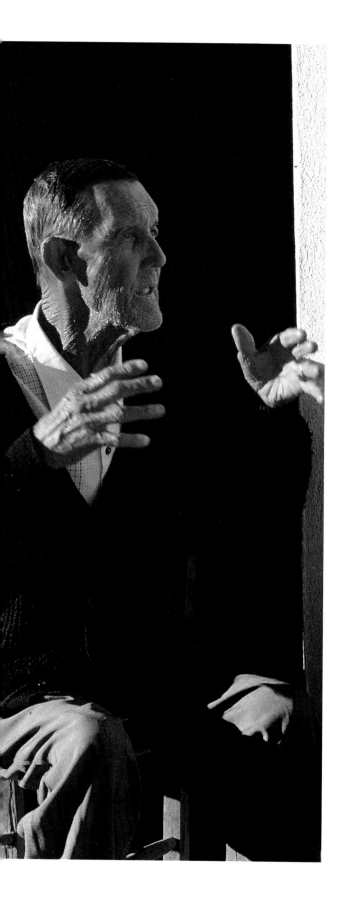

Seventy-year-old Joaquim da Silva, a Brazilian man, described his experience with Africanized bees:

"I went out riding to buy some groceries, and a swarm of bees collided with my horse. I fell off the horse and broke my leg in two places, but I held on to the saddle and used it to cover my head. The bees stung the horse. It was in such pain that it wanted to bite me. Some friends found me and took me to the hospital. The horse walked home, but it died three days later. Thank God I am not dead."

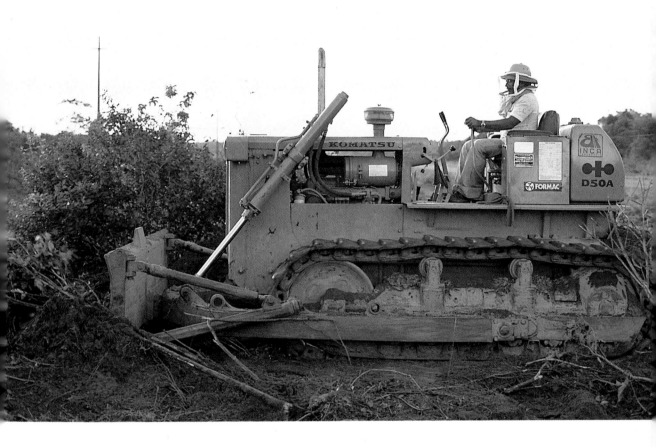

Africanized honeybees also attacked this bulldozer operator. He was moving earth early one morning and bumped their nest. "They stung my head so many times that it swelled. I put the bulldozer in neutral and ran away. The bulldozer stood there running all day. I came back to get it at night when it was dark. Bees don't fly in the dark." Now he wears a bee hat with a veil when he is working, even though it can be uncomfortable in the hot weather.

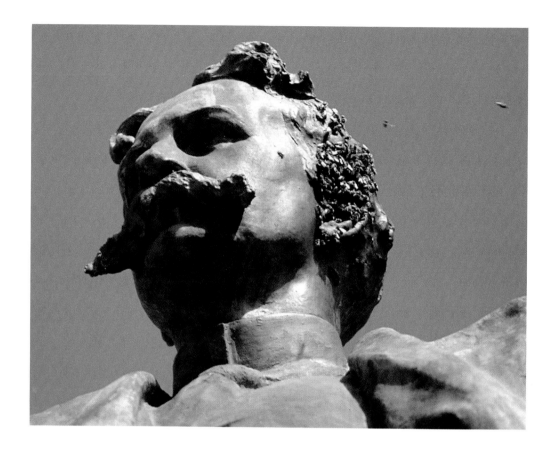

Africanized bees will often build their nests near highly populated places, increasing the likelihood that they will be disturbed. Here a colony has found a spot in the ear of a statue that stands in the middle of a Brazilian city.

Although since 1957 Africanized honeybees have killed hundreds of people in Brazil and elsewhere in the Americas, most of the deaths in Brazil were in the first decade after the bees' emergence. Today there are programs to teach people how to avoid bee attacks, and there are fewer "killer bee" deaths. Each year, about the same number of people are killed by Africanized bees in Brazil as die from an allergic reaction to a beesting in the United States.

The big, brightly painted boulder at the top of the next page says "City of the Bees" in Portuguese. It marks the entrance of a bee-keeping center in southern Brazil where adults and children come to learn some simple safety precautions.

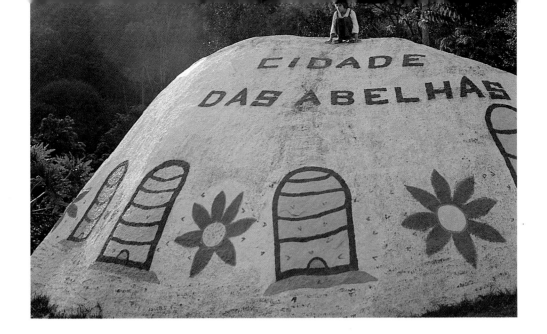

They are told that you should not climb or kick a hollow tree; and if you disturb a nest, run away as fast as possible. People can outrun bees. Never stand still, and don't try to swat the bees away. Run for the protection of a car, a house, even a blanket, which may be thick enough to prevent some of the bees' stingers from reaching your skin.

At the beekeeping center, people also learn how important honeybees are to agriculture. As bees fly among blossoms, seeking nectar and pollen, some of the pollen sticks to the tiny hairs on their bodies. In this way, pollen is spread from flower to flower. This process, called pollination, is the first step in a plant's formation of seeds. Honeybees, millions of which are kept in managed hives, can be taken by beekeepers to the crops that need pollination.

And, of course, bees also make honey. A young visitor learns about the protective suit that a beekeeper wears when checking hives for this sweet, popular food.

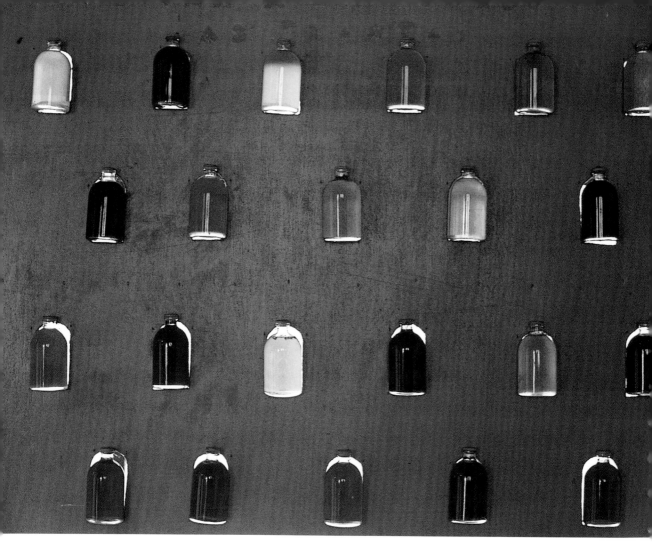

Here a year's worth of honey from one hive has been put in bottles. Depending on what flowers the bees visited, honey can have all the different colors you see in this picture.

To make honey, which is their main food, bees collect nectar, the sweet liquid secreted by flowers. They suck it in with their long, tube-like tongues and store it in a part of their body called the honey stomach. When the bees are full, they return to their nests. There the nectar is passed among the workers. Chemicals in their saliva break the nectar down into simpler sugar. The bees regurgitate the sugary liquid into the waxy cells that make up their nest. Then they beat their wings over the cells to evaporate some of the water, helping the liquid thicken into honey. They cover the cells with wax and store their food for later use.

Africanized honeybees will fly great distances in search of nectar. This is a valuable trait in the tropics, where sources of nectar can be patchy and far apart. But Africanized bees have other characteristics besides aggressive stinging that make them difficult for beekeepers to manage.

A beekeeper wants a colony of bees that will stay in the same wooden hive year after year, devoting most of their efforts to honeymaking. Africanized honeybees use a lot of their energy to reproduce. And for a bee colony to reproduce itself, the queen and most of her workers must fly away to seek a new nest site, leaving a young queen in the old nest. This action is called swarming. It usually happens when the old nest has become too crowded. And because Africanized bee nests tend to be small, they become crowded often.

Africanized bees will also abandon their nests completely, something that European bees rarely do. Absconding, as it is called, usually happens when the nest has been frequently disturbed. This is a particular problem for beekeepers, who handle their hives often as part of their routine honey-collecting and care for the bees.

The traits of frequent swarming and absconding help Africanized bees survive and multiply, but they are bad for beekeepers, who can lose most of their bee populations unless they take special care.

Brazilian beekeepers, who were used to working with docile European bees, had trouble adjusting to the new Africanized honeybee population.

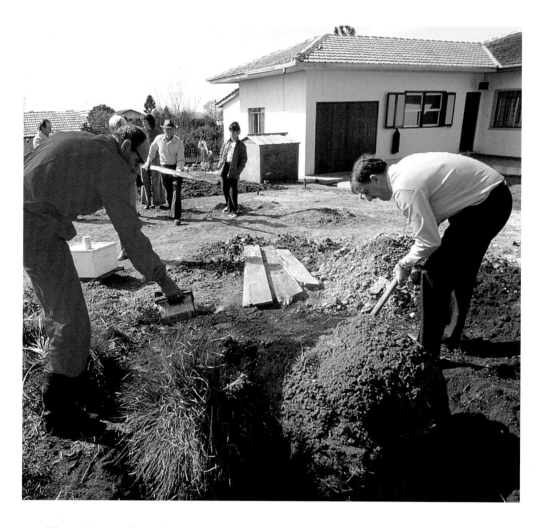

Here is an abandoned termite nest that was buried in a family's garden. Inside this hollow ball, formed of soil and termite saliva, a colony of Africanized honeybees has built its nest. A bee specialist, Dr. Paulo Sommer, and a beekeeper have come to remove the bees.

Because bees cannot see the color red, the suit that beekeeper Antônio Both is wearing helps protect him from them. The men use a smoker to subdue the bees. Smokers and bee suits are important equipment for people working with Africanized bees, but they are expensive. The cost of buying such gear forced many Brazilian beekeepers out of business.

The two men dig up the ball and crack it open. Antônio blows in more smoke to calm the bees.

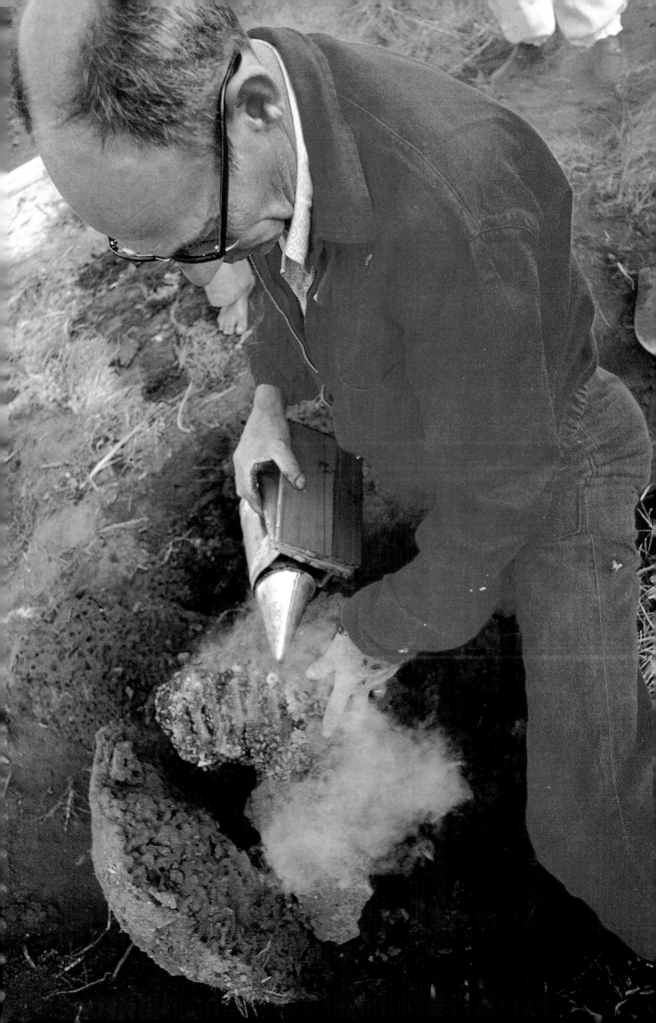

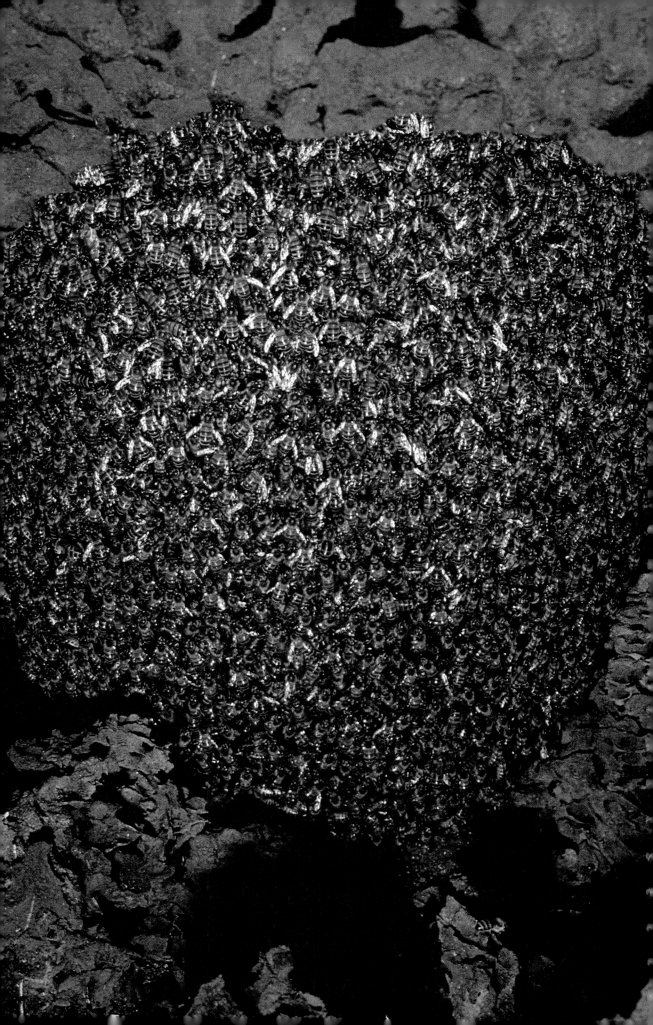

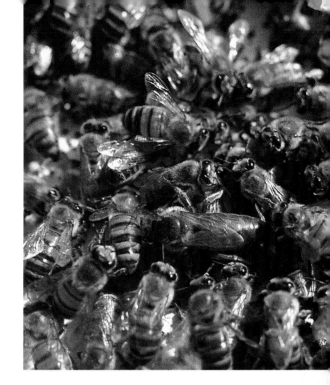

Suddenly, the ball opens completely and exposes the colony hanging from the inside wall. Since the bees have been calmed by smoke, Dr. Sommer is able to search out the queen, pictured at right. As always, she is the largest, and even in the confusion of the moment, most of the workers are turned toward her. Dr. Sommer places her inside a wooden hive, and her worker daughters follow her scent. He will take the hive to an isolated spot where it is unlikely to be disturbed. Beekeeping can no longer take place in populated areas, where people or livestock might accidentally excite the Africanized bees to attack or to abandon their hives. Many Brazilians who once kept hives in their backyards had to give them up.

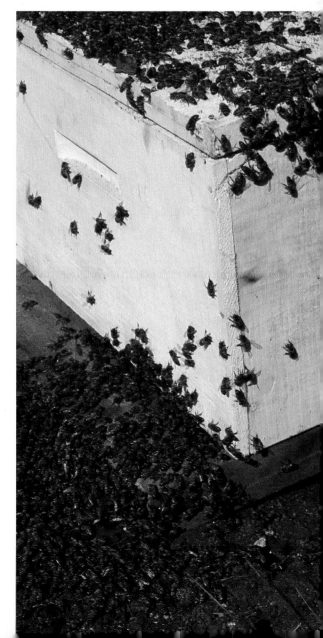

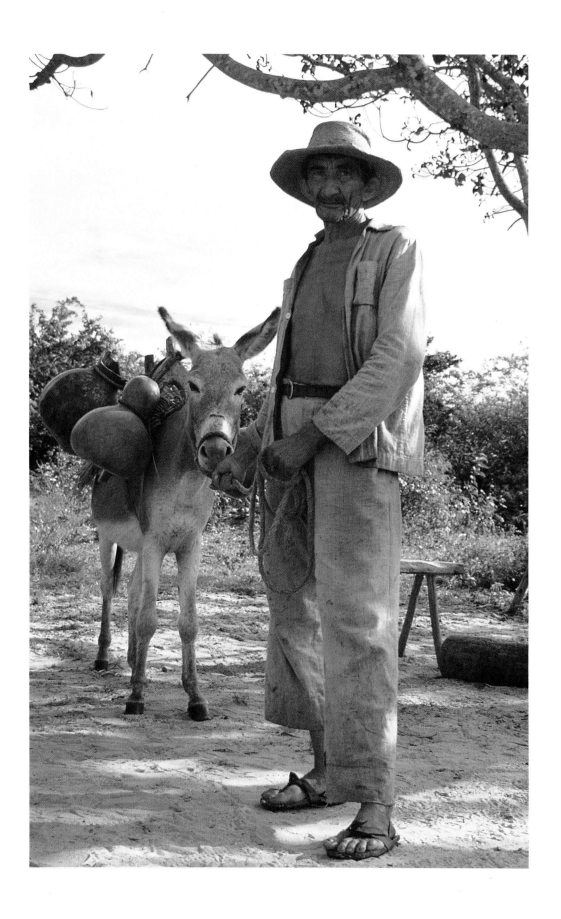

Before African bees were brought to Brazil, there were few colonies of honeybees living in the wild in South America. But because Africanized bees are so well suited to the tropical habitat, there are now wild bee colonies throughout the continent. And for people willing to chance a bee attack, there is a new source of honey.

Francisco Soares da Costa is a *meliero*, or a honey hunter. He lives in a mud hut in northern Brazil with his wife, Maria, seventeen children and grandchildren, lots of chickens, and a donkey.

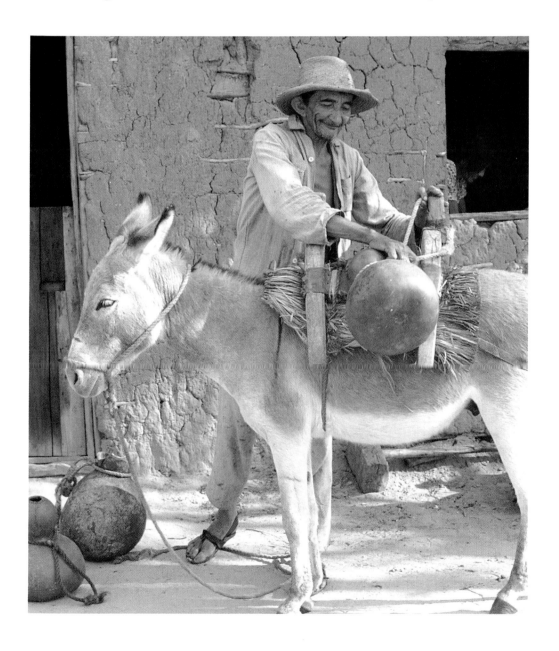

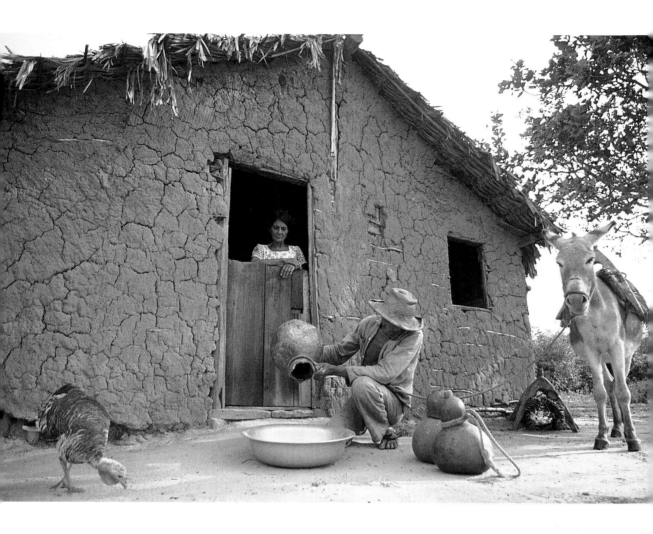

Francisco travels on his donkey, looking for the nests of wild bees. When he finds one, he uses smoke to pacify the bees so he can collect their honey. Despite the smoke, sometimes he is stung so badly that he has a fever all night. He cuts the waxy cells, or honeycomb, from the nest and squeezes the honey by hand into gourd containers that his donkey carries.

When he gets home, he pours the honey into a large pan and picks out any bits of wax. Finally, he pours the honey into bottles, ready to sell.

But the honey season lasts only four months. During that time, Francisco collects about 130 gallons of honey and earns the equivalent of $100—his total income for the year.

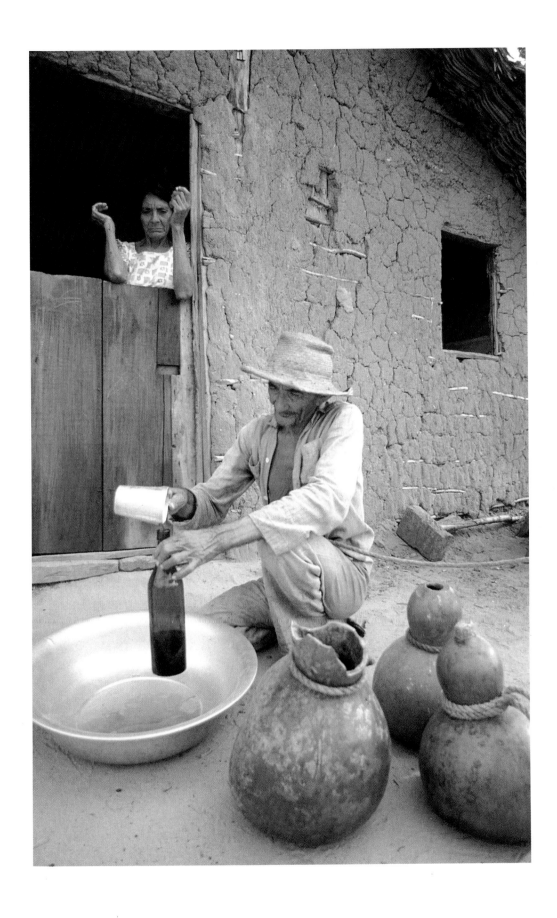

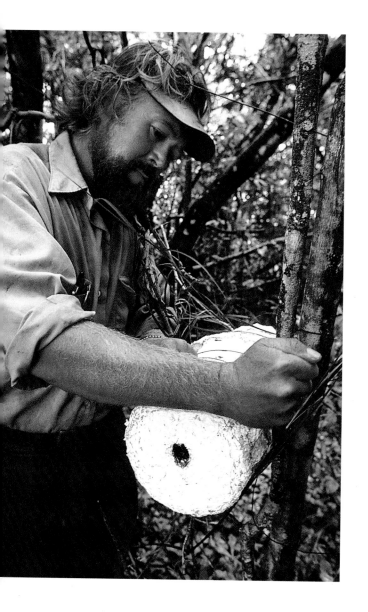

Here in French Guiana, north of Brazil, entomologist Orley Taylor cuts open a bait hive. It was set out to lure Africanized honeybees so Dr. Taylor and other scientists could keep track of their progress northward. Some bait hives are old, used hives that still have the scent of bees and their honey. Others are containers that have been coated with a similar, artificial odor. Honeybees, smelling traces of former occupants, are attracted to the hives as proven good nesting places. But instead of bees, Dr. Taylor finds an angry pygmy possum inside this one.

Pygmy possums are marsupials. Like kangaroos, they carry their young in a pouch. The possums are good climbers and eat the same foods as bees—pollen and nectar. They also pollinate plants as they search for a meal. Lured by the sweet smell of old honey, this possum entered the hive and built a leafy nest.

Based on his work in South America, Dr. Taylor predicted

that Africanized honeybees
would move north toward
the United States at a rate
of about two hundred
miles a year. This has
proven true. And as the
bees have entered each
new area, the local honey-
bee populations have
become "Africanized"
through mating and com-
petition for sources of
food. This has been disrup-
tive to beekeeping—many
beekeepers have given up

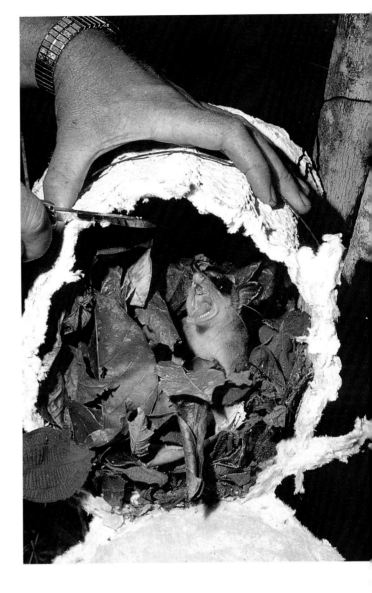

their hives because they do not know how to work with African-
ized bees.

The volatile temperament of the Africanized bees also makes
them difficult to use for crop pollination. Before the arrival of
Africanized bees, farmers could pay beekeepers to bring their
European bees to a field that needed pollination. But Africanized
bees do not respond well to having their hives moved. They are
likely to sting any field-workers nearby or abandon their hives,
causing a great financial loss to the beekeeper.

To help beekeepers develop a milder type of bee, scientists are exploring methods such as crossbreeding. Here Professor Lionel Sequi Gonçalves is artificially inseminating an Africanized queen with the sperm of a European drone to make her offspring more docile. But scientists can do little to stop the bees from migrating as far north as the climate permits.

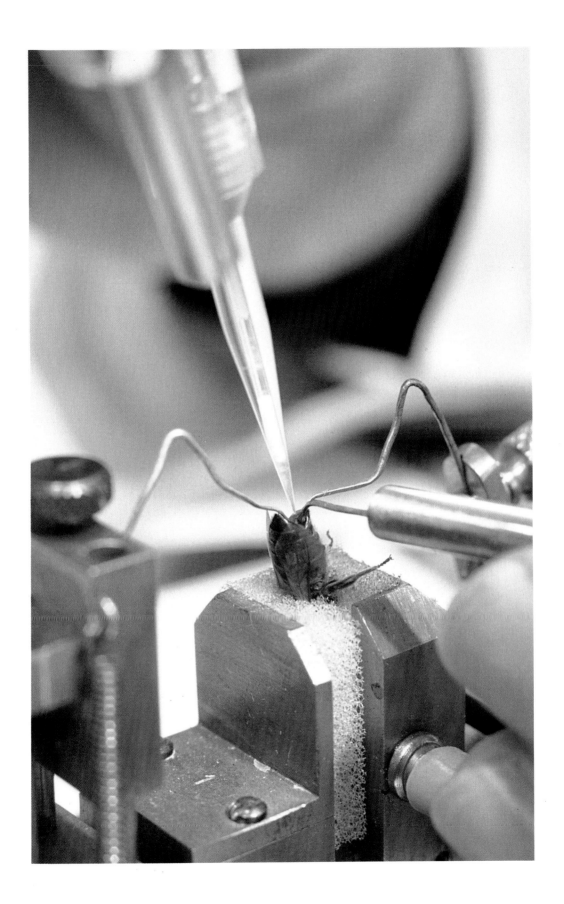

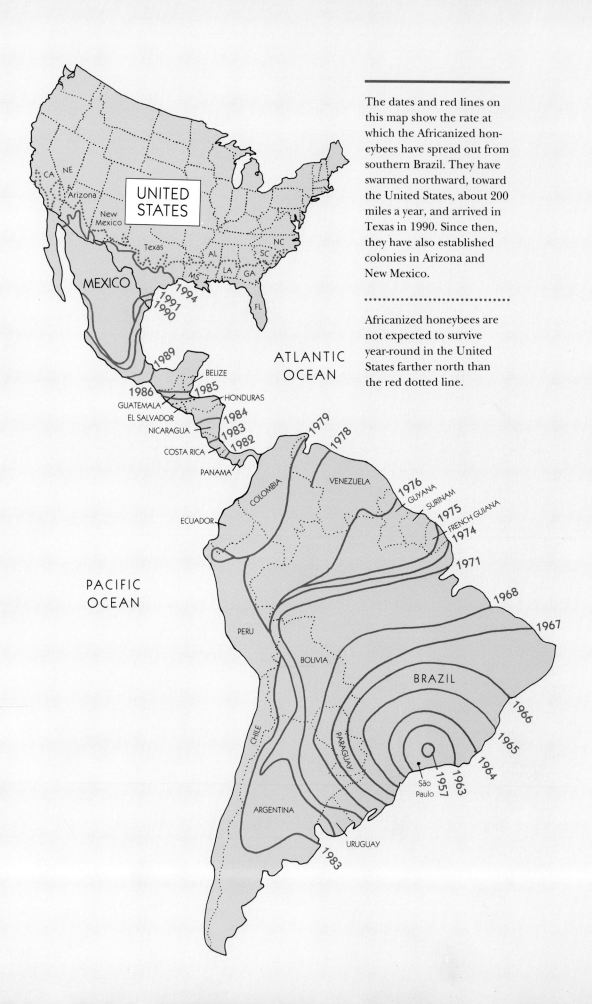

UNITED STATES

CA
NE
Arizona
New Mexico
Texas
AL
NC
SC
MS
LA
GA
MEXICO
FL

1994
1991
1990
1989

BELIZE
1986
1985
HONDURAS
GUATEMALA
EL SALVADOR
1984
NICARAGUA
1983
1982
COSTA RICA
PANAMA

ATLANTIC
OCEAN

The dates and red lines on this map show the rate at which the Africanized honeybees have spread out from southern Brazil. They have swarmed northward, toward the United States, about 200 miles a year, and arrived in Texas in 1990. Since then, they have also established colonies in Arizona and New Mexico.

Africanized honeybees are not expected to survive year-round in the United States farther north than the red dotted line.

1979
1978
COLOMBIA
VENEZUELA
1976
GUYANA
SURINAM
1975
FRENCH GUIANA
1974
ECUADOR
1971
PACIFIC
OCEAN
1968
1967
PERU
BOLIVIA
BRAZIL
1966
1965
1964
CHILE
PARAGUAY
1963
1957
São Paulo
ARGENTINA
1983
URUGUAY

The Africanized honeybees reached Texas in 1990 and had spread to Arizona and New Mexico by 1993. They are expected to establish colonies throughout much of the United States in the warm summer months. But cold weather will prevent them from living year-round any farther north than Southern California and the Carolinas. They do not survive well in areas where the average temperatures fall below sixty degrees Fahrenheit during the winter. Because their colonies are usually small, they cannot cluster in huge groups, as European honeybees do to maintain the heat needed to survive the cold.

Africanized honeybees are in the Americas to stay. Brazilians have learned to live safely with the bees. And Brazilian beekeepers are beginning to get the large amounts of honey from their hives that they sought so many years ago. We can learn to live and work with the bees, too. The most important thing to remember is that Africanized honeybees are not monsters with a grudge against humankind. They are insects that sting only to defend themselves, and they have adapted remarkably well to a tropical environment.

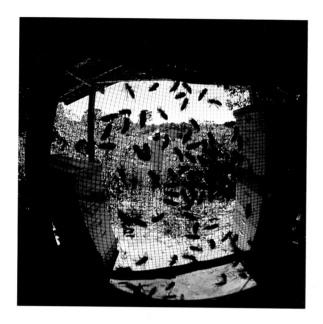

"I could not wear perfume because the bees went after smelly things like perfume or sweaty horses," says Bianca Lavies, who photographed the killer bees nineteen years after the first African bees arrived in Brazil.

"They were ferocious when they came out to defend their colony. All I had to do was set up the tripod for my camera, and they were humming around me by the thousands, dive-bombing my face and stinging my protective suit. I panicked when I felt a sting on my cheek. It was sore. I worried that they were getting inside my veil; I couldn't see if they were crawling on the inside or the outside. The picture above (at left) shows the view from behind my veil.

"'I'm stung,' I said and turned around. No one in my group was behind me anymore. I took a few steps toward the car, but then I thought about my pictures and what I was missing. I went back and continued my work—and received two more stings on the cheek! (See picture above.) Later, approaching another colony, I was more careful. I put tape over my cheeks and was not stung that time.

"I was not able to change lenses on any of my cameras, as the bees were looking for holes to go into. Each time I pressed my camera shutter, I squashed a dozen bees. When we finally drove off, the whole car was full of bees. They were crawling all over the inside of the windows. After a while, we stopped to chase them out of the car.

"Afterward, my equipment bags were full of dead bees, and I even found a squashed bee inside my camera. There are still thousands of unremovable stingers in my gloves, souvenirs of an unforgettable experience."